For Ken, with thanks - a very good idea indeed

First Edition April 2013

Published by **two little birds**,
an imprint of Peter E. Randall Publisher LLC,
PO Box 4726, Portsmouth, NH 03802

www.twolittlebirdsbooks.com

ISBN 13: 978-1-931807-74-6

Library of Congress Control Number: 2012954682

Production Date 02/01/2013
Plant & Location Printed by Everbest Printing
 (Guangzhou, China), Co Ltd.
Job/Batch # 111700.3

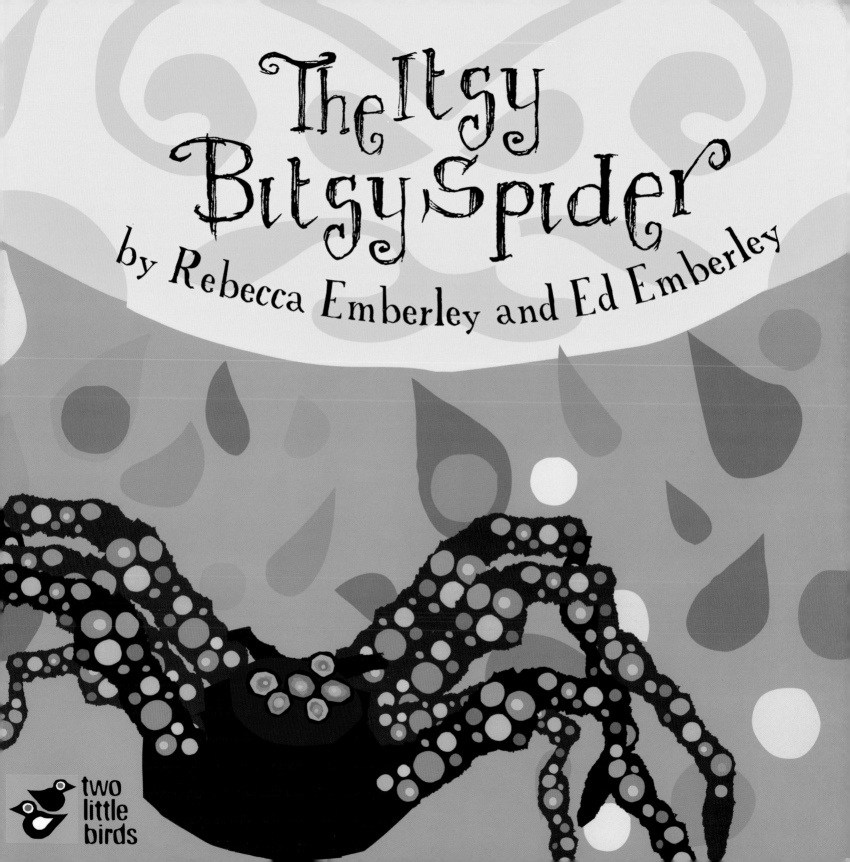

The itsy bitsy spider

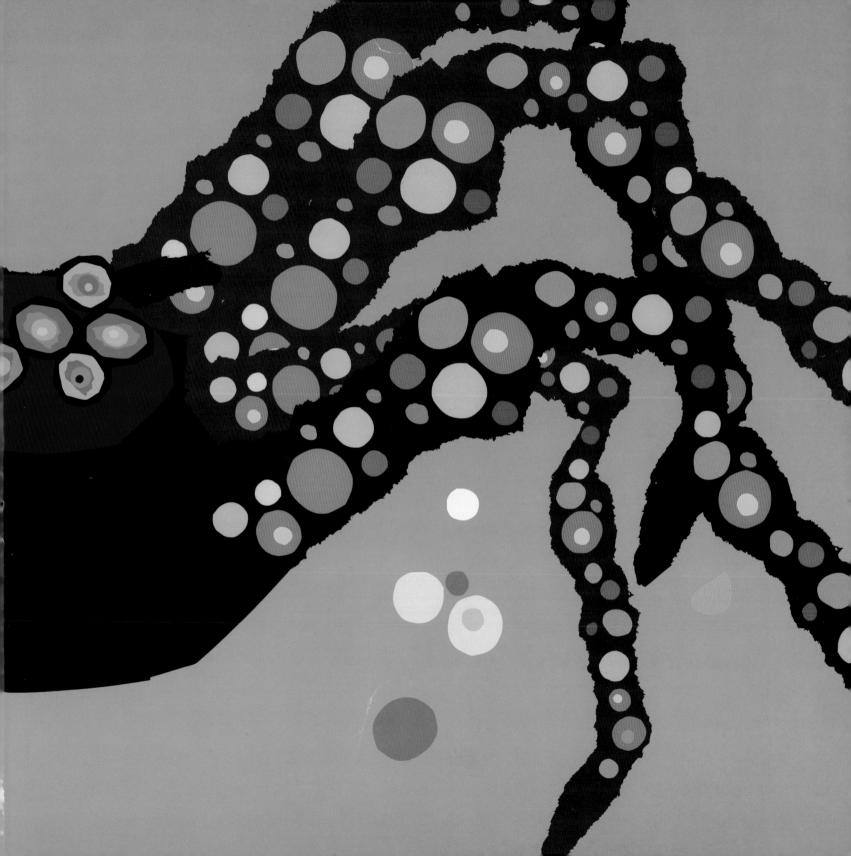

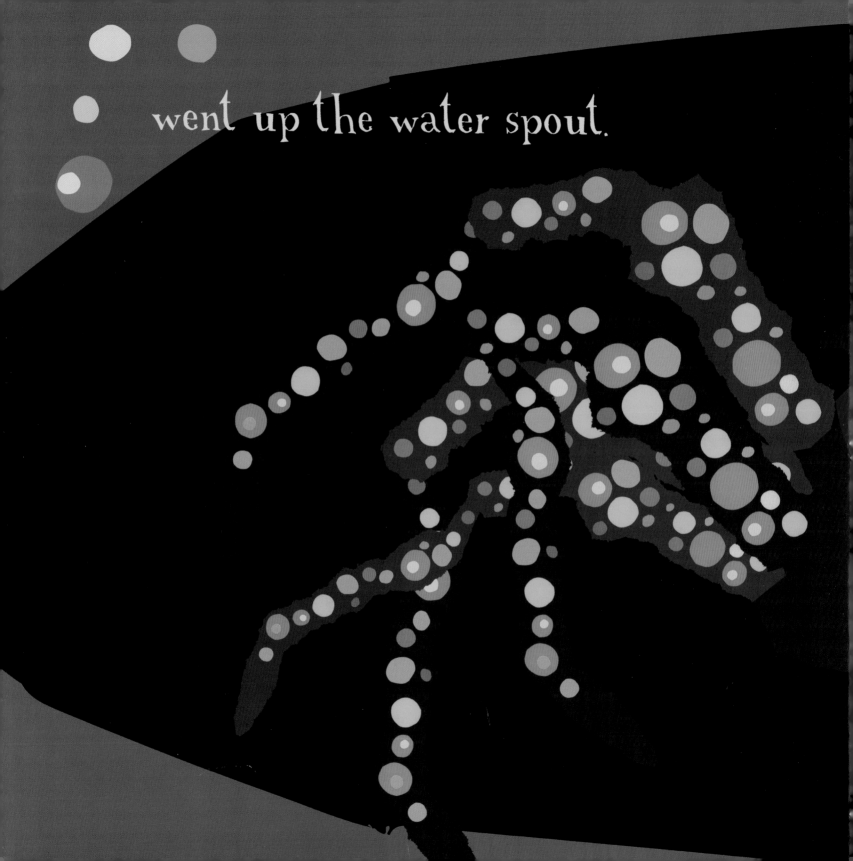

went up the water spout.

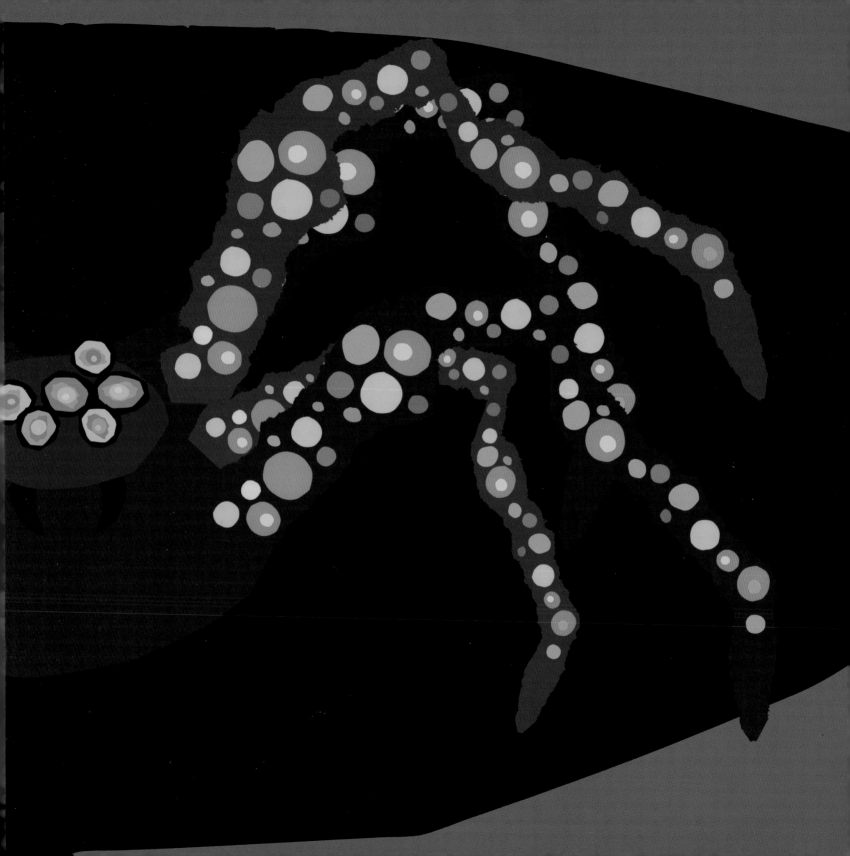

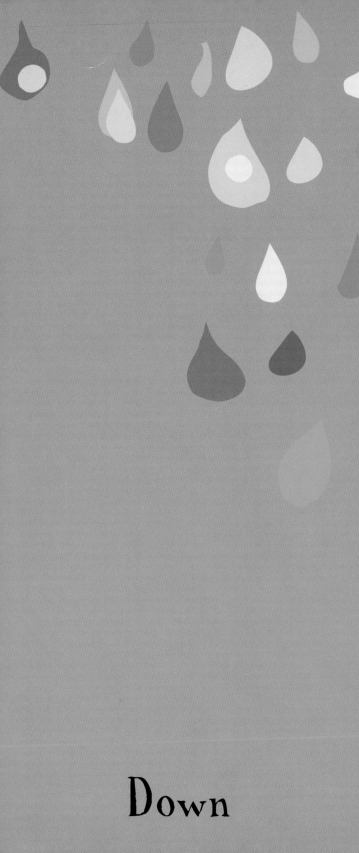

Down came

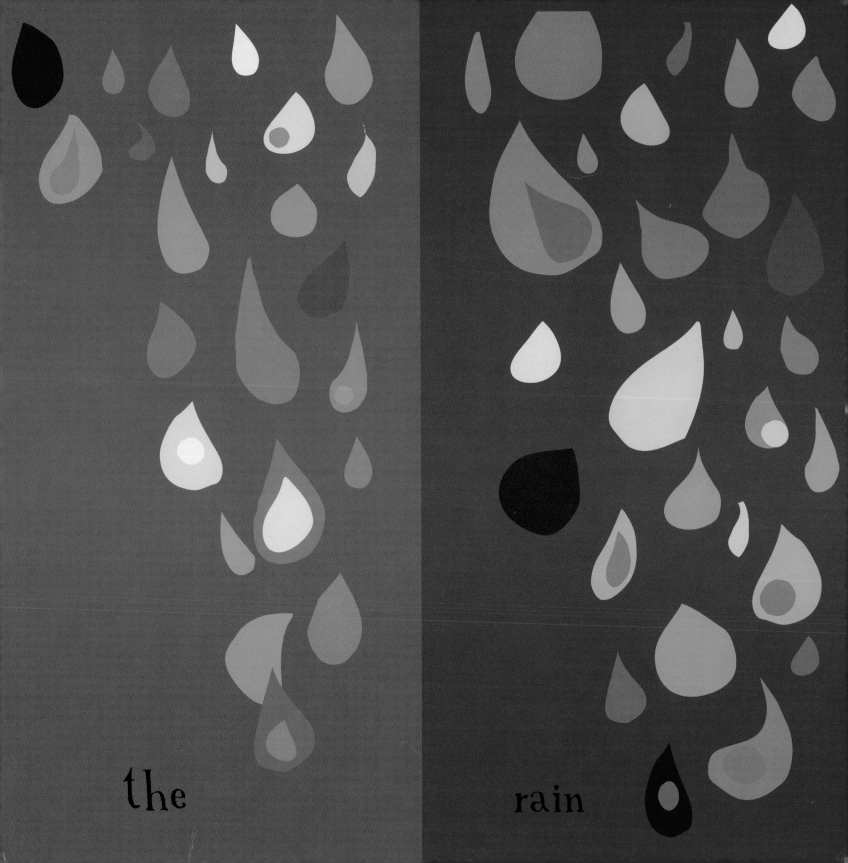

the

rain

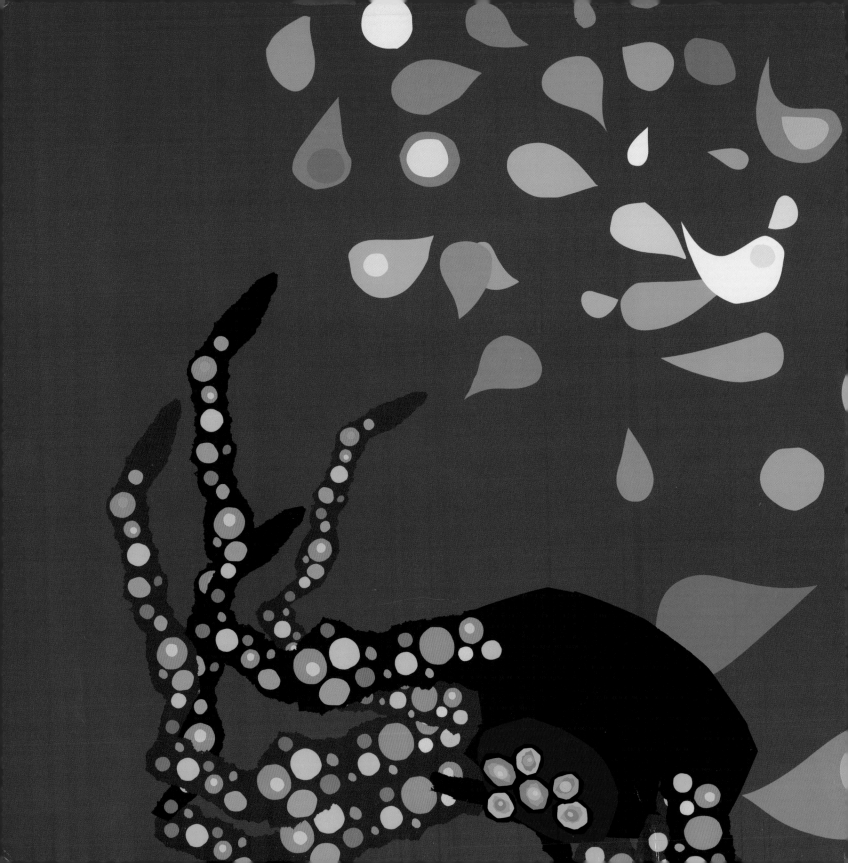

and washed the spider out.

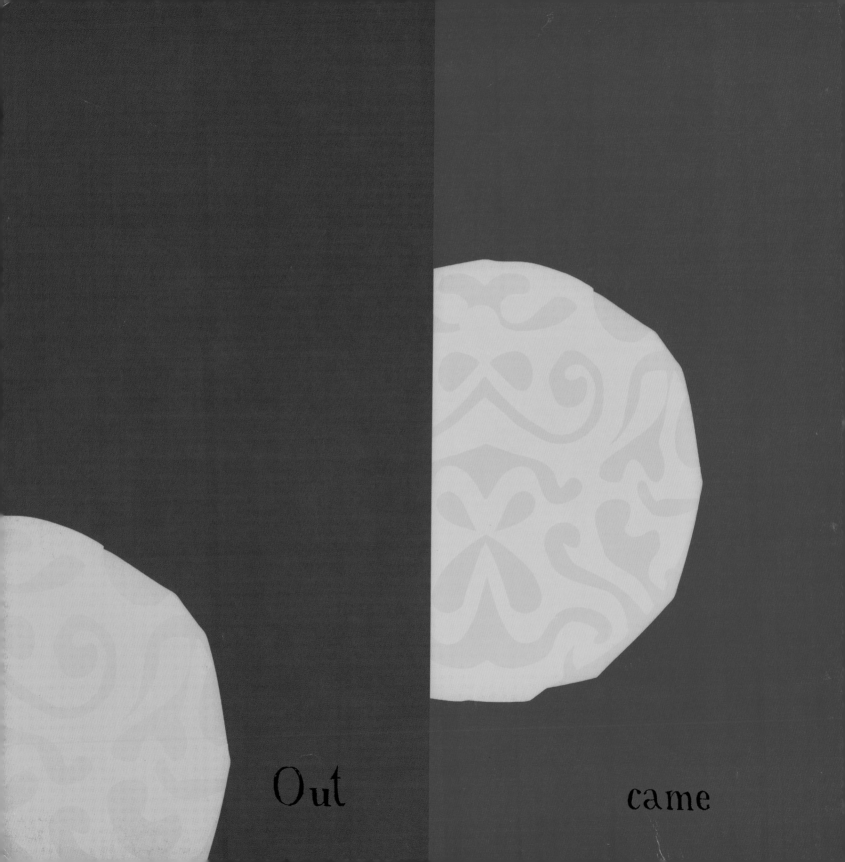

Out

came

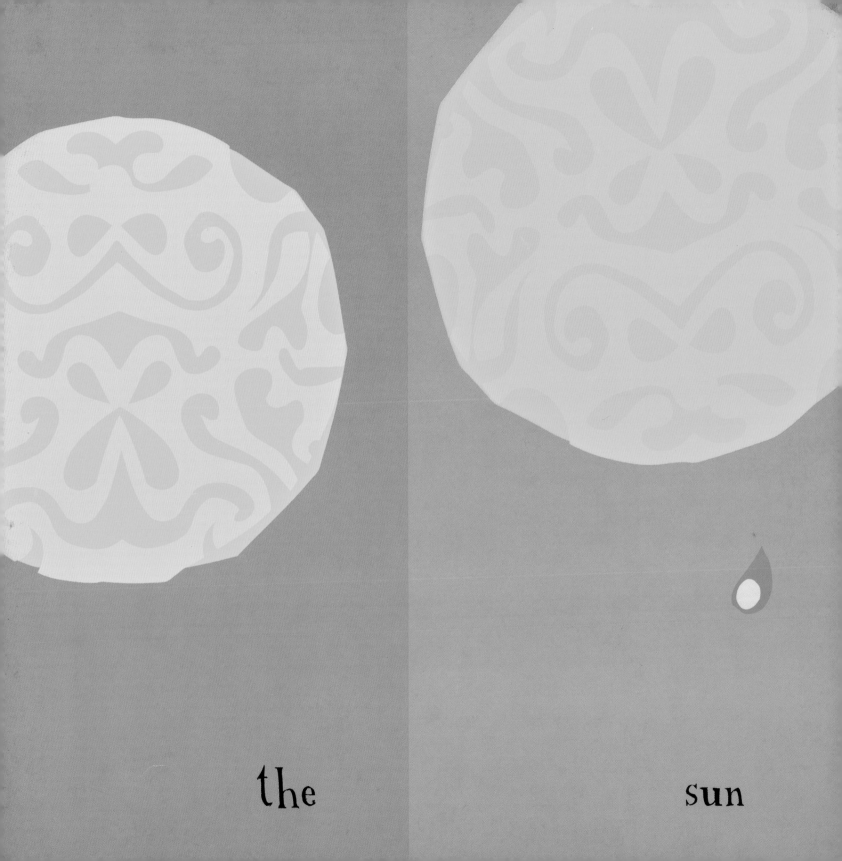

the sun

and dried up all the rain.

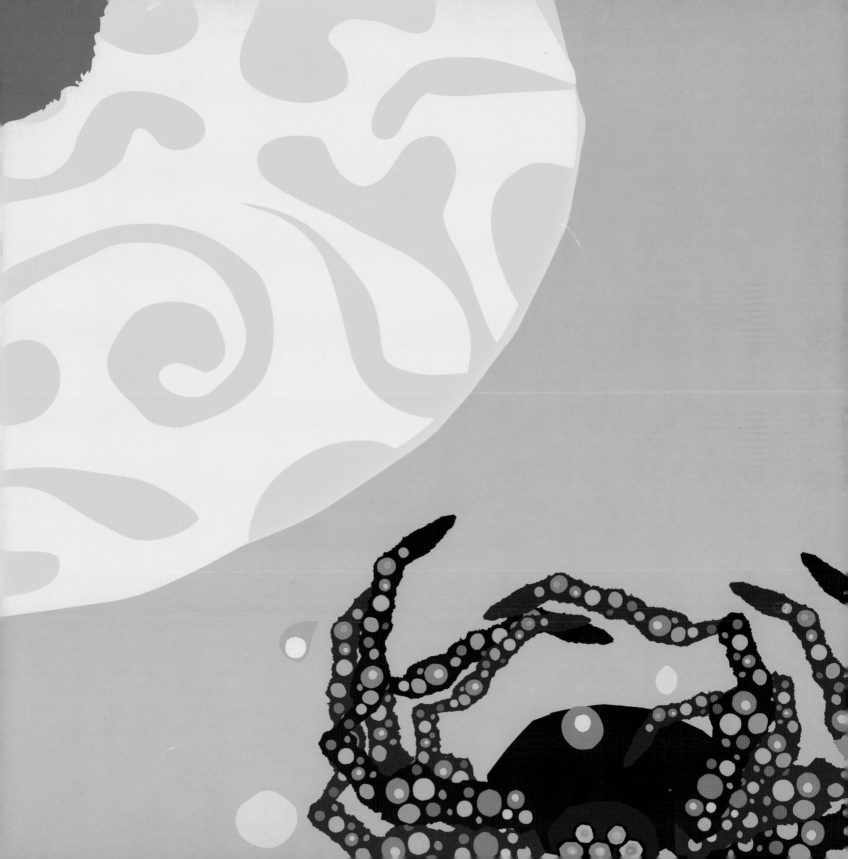

and the itsy bitsy spider

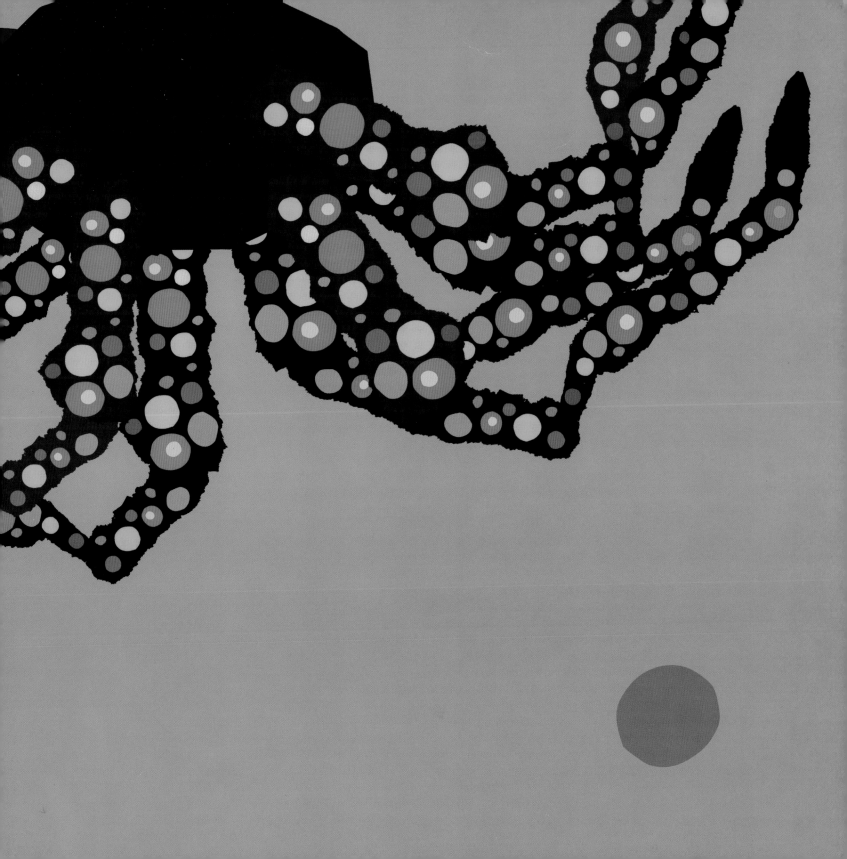

went up the spout again.

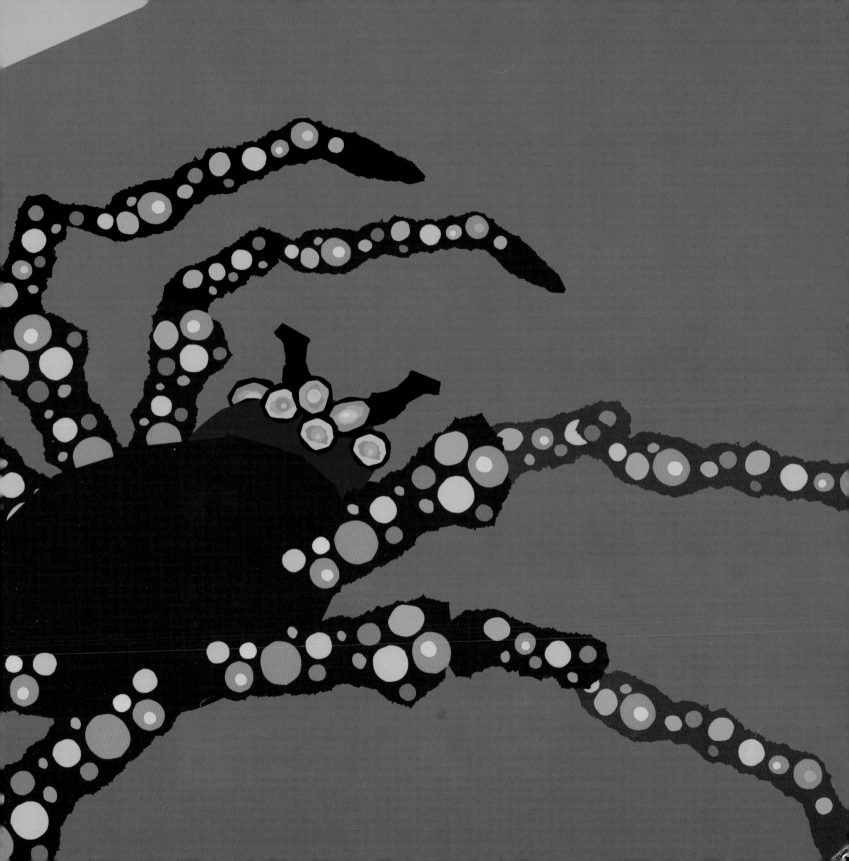